THIS BOOK BELONGS TO

ETTA

deaf
elephants

William Benton

Bill Benton

Pomegranate

SAN FRANCISCO

Published by Pomegranate Communications, Inc.
Box 6099, Rohnert Park, California 94927
800 277 1428; www.pomegranate.com

Pomegranate Europe Ltd.
Fullbridge House, Fullbridge
Maldon, Essex CM9 4LE, England

Library of Congress Cataloging-in-Publication Data
Benton, William, 1939.
 Deaf elephants / William Benton.
 p. cm.
 ISBN 0-7649-2023-5 (alk. paper)
 1. Title.

 PS3552.E59 D43 2001
 818'.5407—dc21

 2001051384

Pomegranate Catalog No. A627

Cover and book design by Lynn Bell, Monroe Street Studios

Printed in China

10 09 08 07 06 05 04 03 02 01 10 9 8 7 6 5 4 3 2 1

For Jessica

Deaf elephants like ordinary
elephants, come from two different
parts of the world.

India

And Africa.

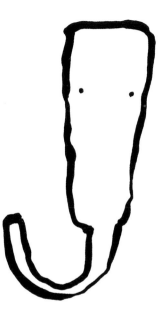

Deaf elephants are easy to recognize.

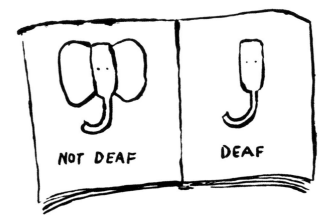

NOT DEAF DEAF

They can, at times, develop excellent tusks,

But in general the deaf elephant produces quite small tusks or none at all.

Their temperments vary from elephant to elephant. Some, like this young male, are playful and impetuous.

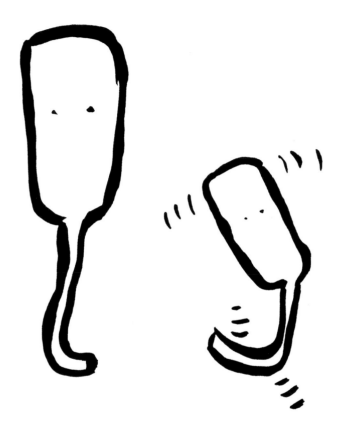

While others show a grave, slightly puzzled demeanor,

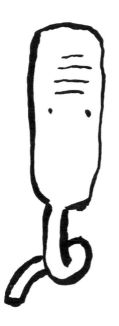

And others seem content to ponder the giant silence.

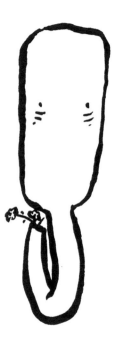

Deaf elephants are vulnerable.

Ruthless hunters with deaf
elephant guns stalk them
from behind,

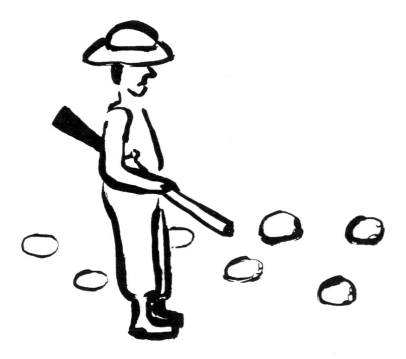

And one will sometimes crumple soundlessly to the ground.

Deaf elephants communicate their thoughts by staring into each other's eyes.

Huge sad thoughts,

Or deep profound thoughts,

But usually their thoughts are light as clouds and few and happy.

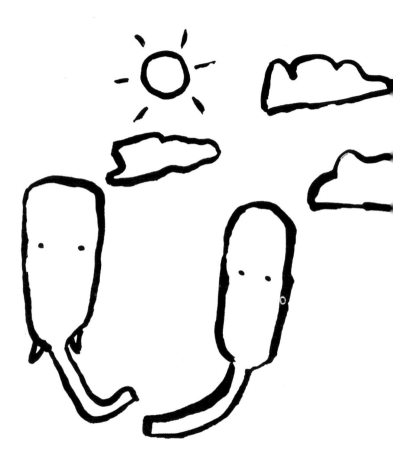

Deaf elephants fall in love.

One will stand in front of the moon, dreaming.

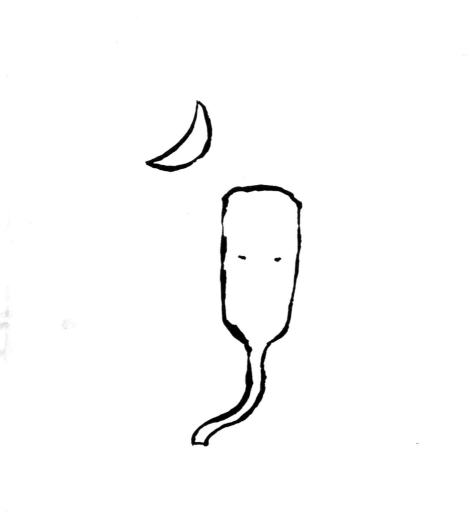

Another will say, "How beautiful you look tonight."

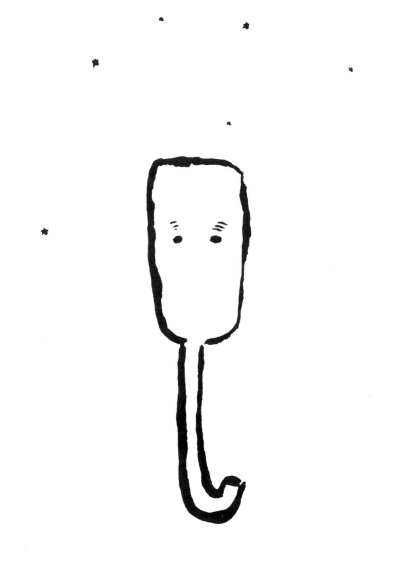

And then they will dance to
an imagined music,

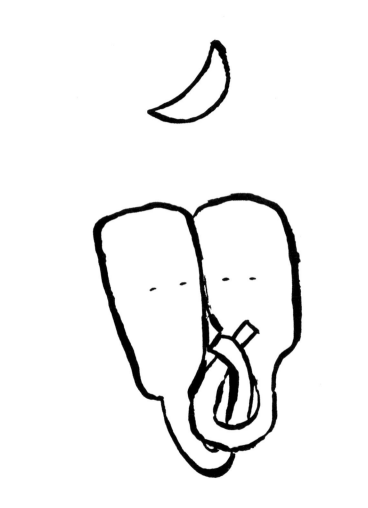

The stars twirling and glittering above them.

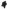

Deaf elephants are born that way.

The young elephants quickly learn that the air is full of whispers and roars which they will never hear.

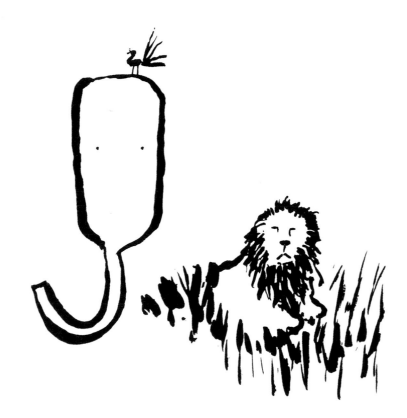

At first they are shy and try to disguise their condition.

Elephants with ears look down their noses at them.

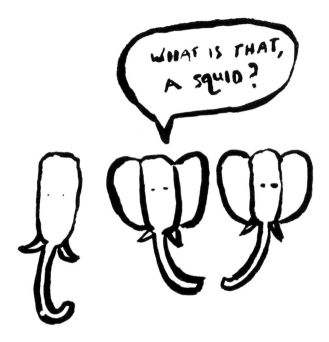

Zoos exclude them.

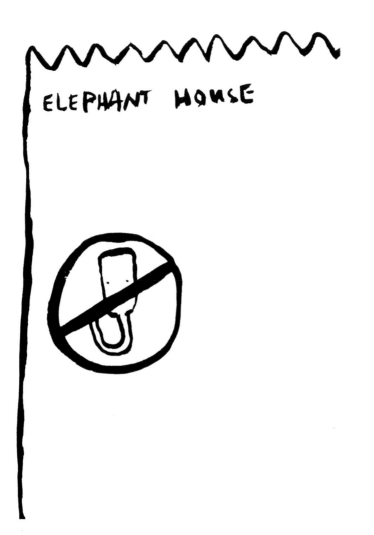

ELEPHANT HOUSE

Nevertheless, the deaf elephants soon accept their weird appearance and difficult destiny,

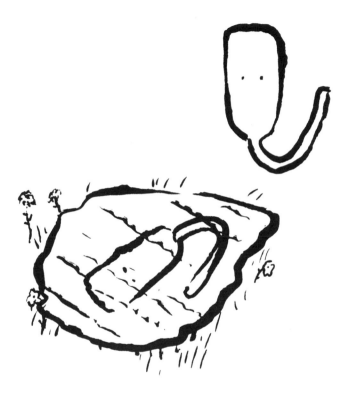

And with the courage of their
huge elephant hearts happily begin
to take their place in the world.

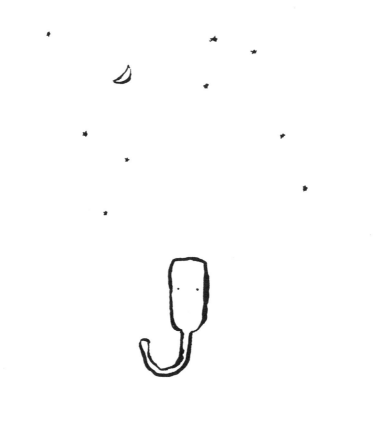